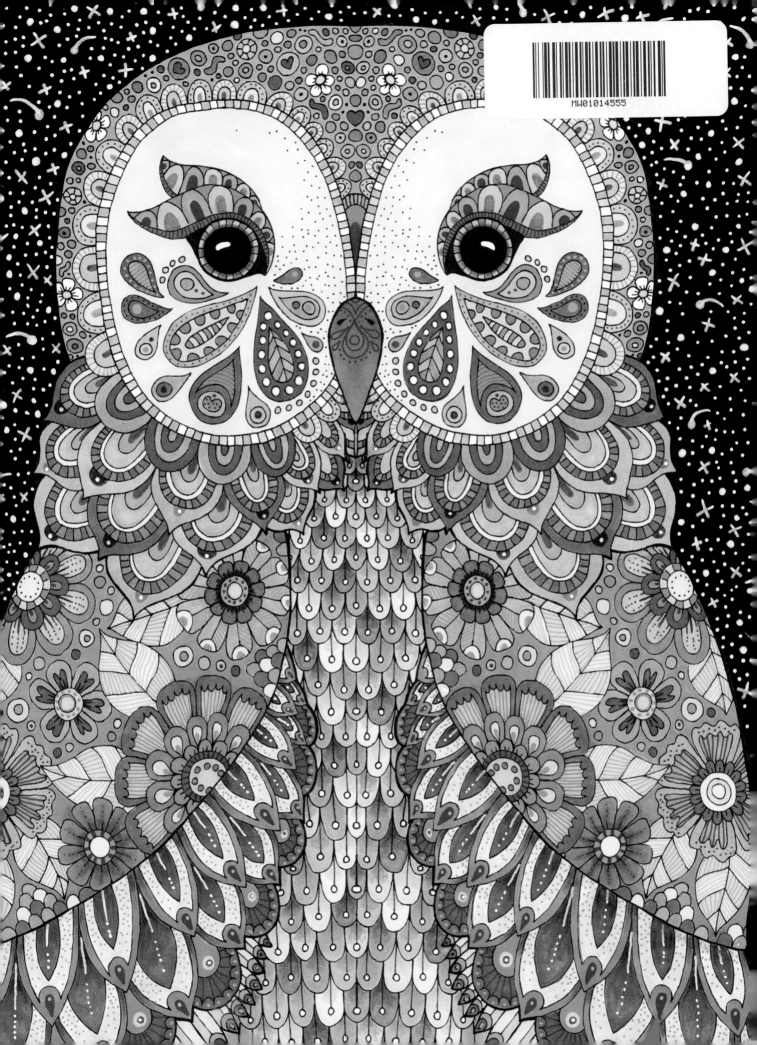

What's My Style?

I love creating elaborate patterns packed with detail so I can do lots of intricate coloring. I try to use as many colors as possible. Then, I layer on lots of fun details. Here are some more examples of my work.

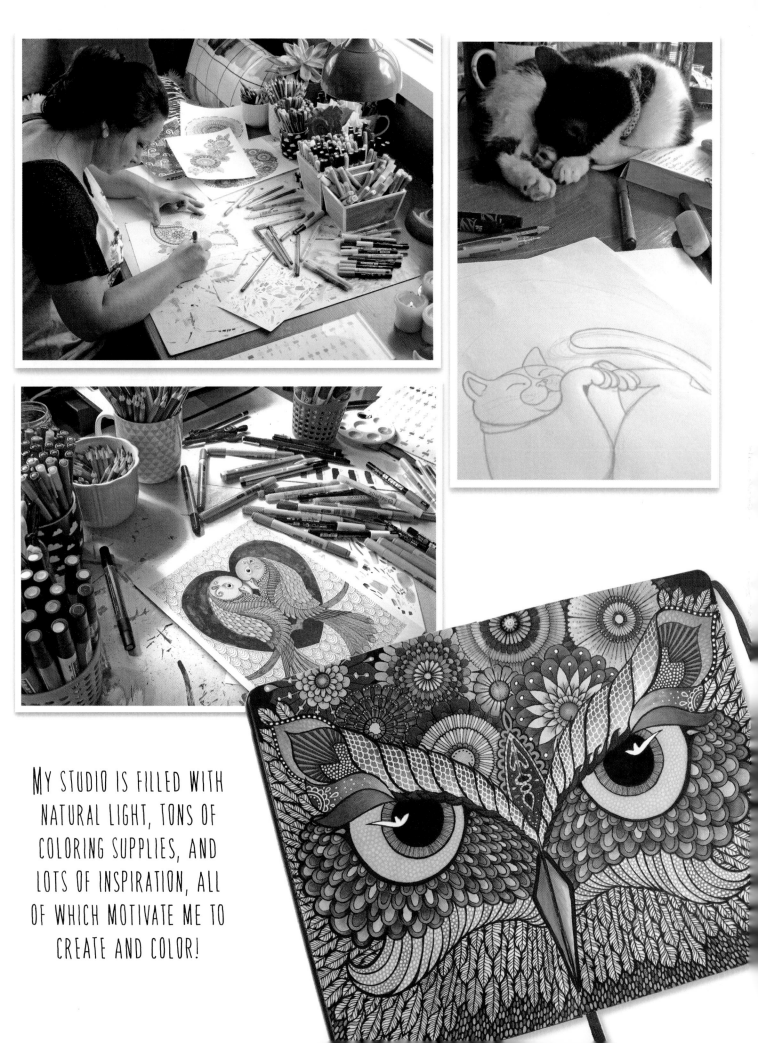

My studio is filled with natural light, tons of coloring supplies, and lots of inspiration, all of which motivate me to create and color!

Where To Start

You might find putting color on a fresh page stressful. It's ok! Here are a few tricks I use to get the ink flowing.

Start with an easy decision. If a design has leaves, without a doubt, that's where I start. No matter how wacky and colorful everything else gets, I always color the leaves in my illustrations green. I have no reason for it, it's just how it is! Try to find something in the design to help ground you by making an easy color decision: leaves are green, the sky is blue, etc.

Get inspired. Take a good look at everything in the illustration. You chose to color it for a reason. One little piece that you love will jump out and say, "Color me! Use red, please!" Or maybe it will say blue, or pink, or green. Just relax—it will let you know.

Follow your instincts. What colors do you love? Are you a big fan of purple? Or maybe yellow is your favorite. If you love it, use it!

Just go for it. Close your eyes, pick up a color, point to a spot on the illustration, and start! Sometimes starting is the hardest part, but it's the fastest way to finish!

Helpful Hints

There is no right or wrong. All colors work together, so don't be scared to mix it up. The results can be surprising!

Try it. Test your chosen colors on scrap paper before you start coloring your design. You can also test blending techniques and how to use different shapes and patterns for detail work—you can see how different media will blend with or show up on top of your chosen colors. I even use the paper to clean my markers or pens if necessary.

Make a color chart. A color chart is like a test paper for every single color you have! It provides a more accurate way to choose colors than selecting them based on the color of the marker's cap. To make a color chart, color a swatch with each marker, colored pencil, gel pen, etc. Label each swatch with the name or number of the marker so you can easily find it later.

Do you like
warm colors?

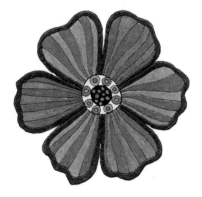

How about cool colors?

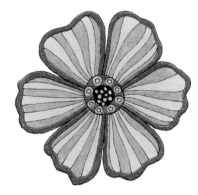

Maybe you like warm and
cool colors together!

Keep going. Even if you think you've ruined a piece, work through it. I go through the same cycle with my coloring: I love a piece at the beginning, and by the halfway point I nearly always dislike it. Sometimes by the end I love it again, and sometimes I don't, and that's ok. It's important to remember that you're coloring for you— no one else. If you really don't like a piece at the end, stash it away and remember that you learned something. You know what not to do next time. My studio drawers are full of everything from duds to masterpieces!

Be patient. Let markers, gel pens, and paints dry thoroughly between each layer. There's nothing worse than smudging a cluster of freshly inked dots across the page with your hand. Just give them a minute to dry and you can move on to the next layer.

Use caution. Juicy/inky markers can "spit" when you uncap them. Open them away from your art piece.

Work from light to dark. It's much easier to make something darker gradually than to lighten it.

Shade with gray. A mid-tone lavender-gray marker is perfect for adding shadows to your artwork, giving it depth and making it pop right off the page!

Try blending fluid. If you like working with alcohol-based markers, a refillable bottle of blending fluid or a blending pen is a great investment. Aside from enabling you to easily blend colors together, it can help clean up unwanted splatters or mistakes—it may not take some colors away completely, but it will certainly lighten them. I use it to clean the body of my markers as I'm constantly smudging them with inky fingers. When a marker is running out of ink, I find adding a few drops of blending fluid to the ink barrel will make it last a bit longer.

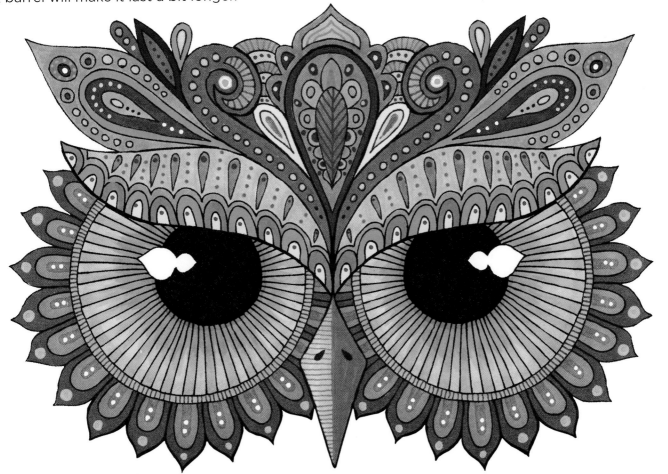

Layering and Blending

I love layering and blending colors. It's a great way to create shading and give your finished piece lots of depth and dimension. The trick is to work from the lightest color to the darkest and then go over everything again with the lightest shade to keep the color smooth and bring all the layers together.

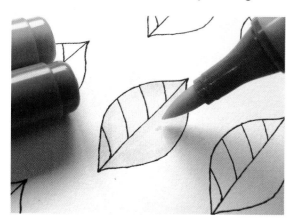

1 Apply a base layer with the lightest color.

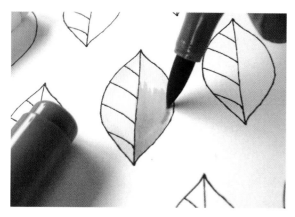

2 Add the middle color, using it to create shading.

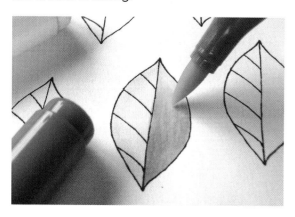

3 Smooth out the color by going over everything with the lightest color.

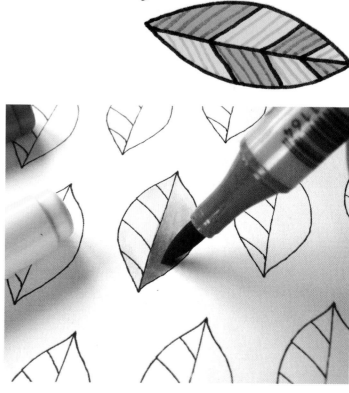

4 Add the darkest color, giving your shading even more depth. Use the middle color to go over the same area you colored in Step 2.

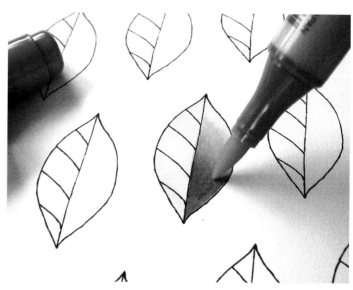

5 Go over everything with the lightest color as you did in Step 3.

Patterning and Details

Layering and blending will give your coloring depth and dimension. Adding patterning and details will really bring it to life. If you're not convinced, try adding a few details to one of your colored pieces with a white gel pen—that baby will make magic happen! Have fun adding all of the dots, doodles, and swirls you can imagine.

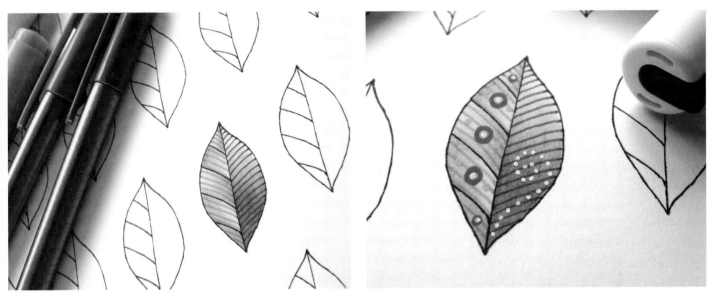

1 Once you've finished your coloring, blending, and layering, go back and add simple patterning like lines or dots. You can add your patterns in black or color. For this leaf, I used two different shades of green pen.

2 Now it's time to add some fun details using paint pens or gel pens. Here, I used white, yellow, and more green.

This design really pops with lots of patterning and little details.

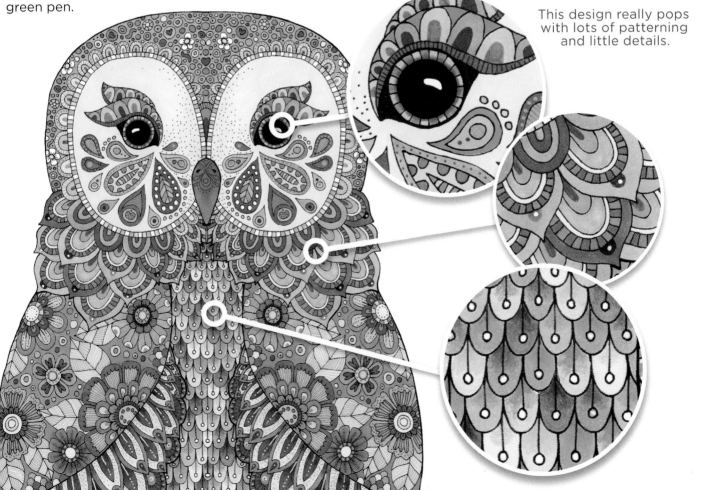

Coloring Supplies

I'm always asked about the mediums I use to color my illustrations. The answer would be really long if I listed every single thing, so here are a few of my favorites. Keep in mind, these are *my* favorites. When you color, you should use YOUR favorites!

Alcohol-based markers. I have many, and a variety of brands. My favorites have a brush nib—it's so versatile. A brush nib is perfect for tiny, tight corners, but also able to cover a large, open space easily. I find I rarely get streaking, and if I do, it's usually because the ink is running low!

Fine-tip pens. Just like with markers, I have lots of different pens. I use them for my layers of detail work and for the itsy bitsy spots my markers can't get into.

Paint pens. These are wonderful! Because the ink is usually opaque, they stand out really well against a dark base color. I use extra fine point pens for their precision. Some paint pens are water based, so I can use a brush to blend the colors and create a cool watercolor effect.

Gel pens. I have a few, but I usually stick to white and neon colors that will stand out on top of dark base colors or other mediums.

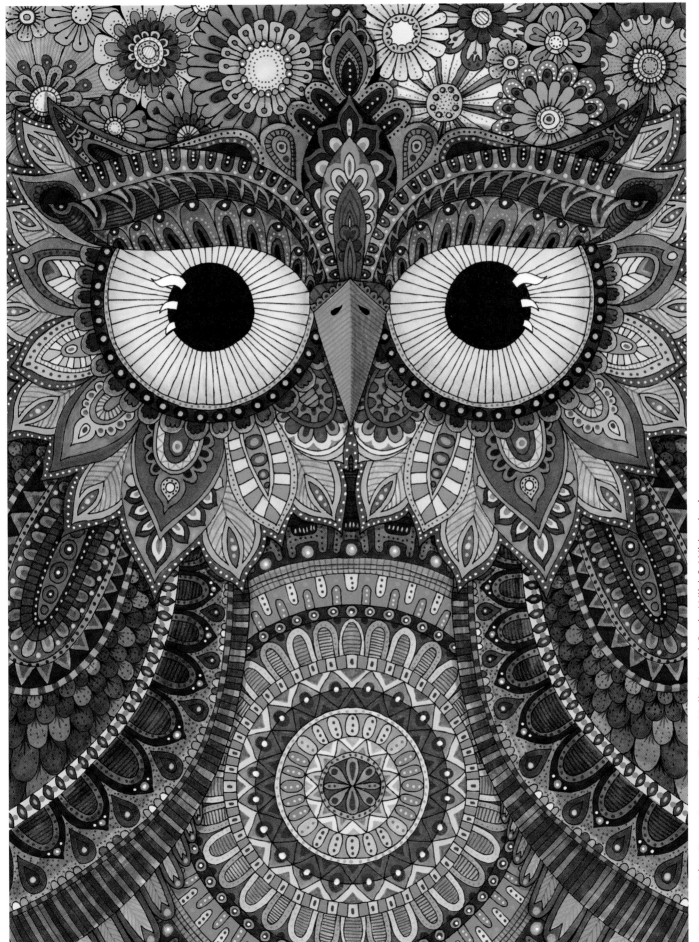

Hello Angel #1219, liquid watercolor, markers, colored pencils, pens, paint pens

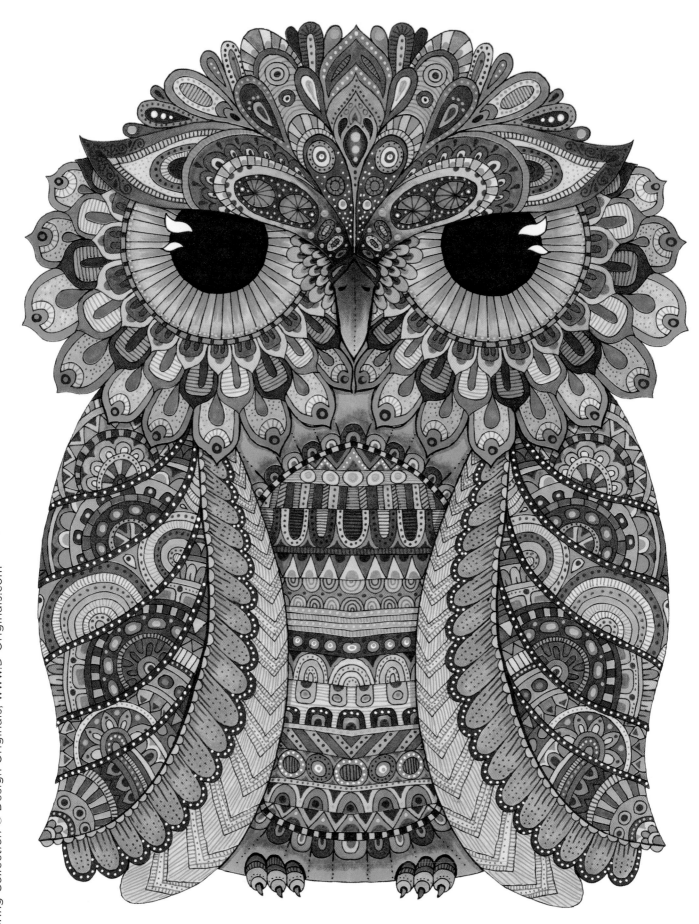

Hello Angel #1218, markers, colored pencils, pens, paint pens

Hello Angel #1201, liquid watercolor, markers, colored pencils, pens, paint pens

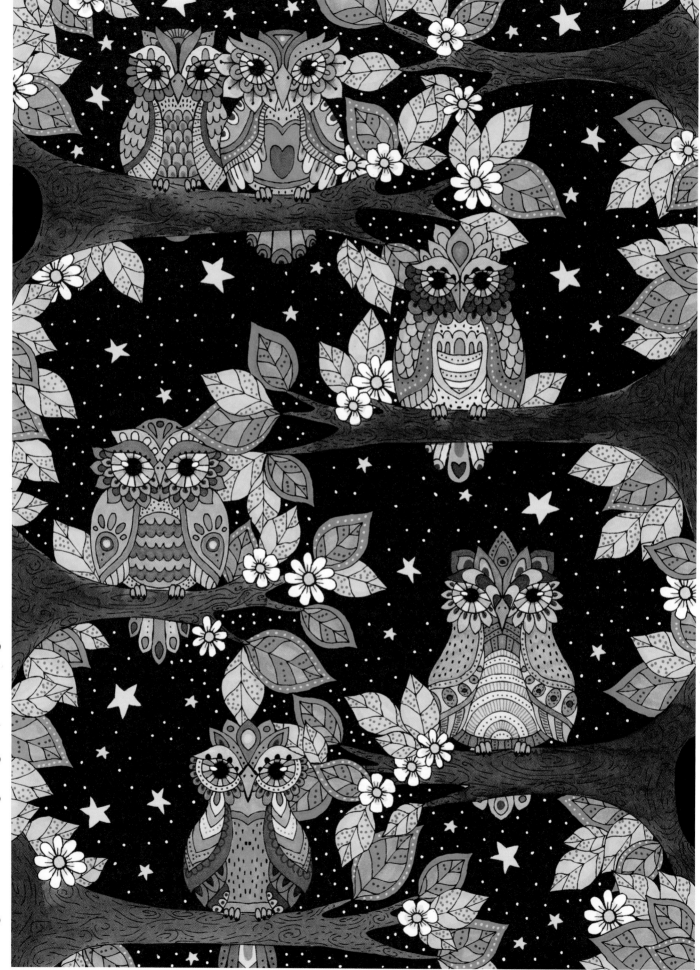

Hello Angel #1220, liquid watercolor, markers, colored pencils, pens, paint pens

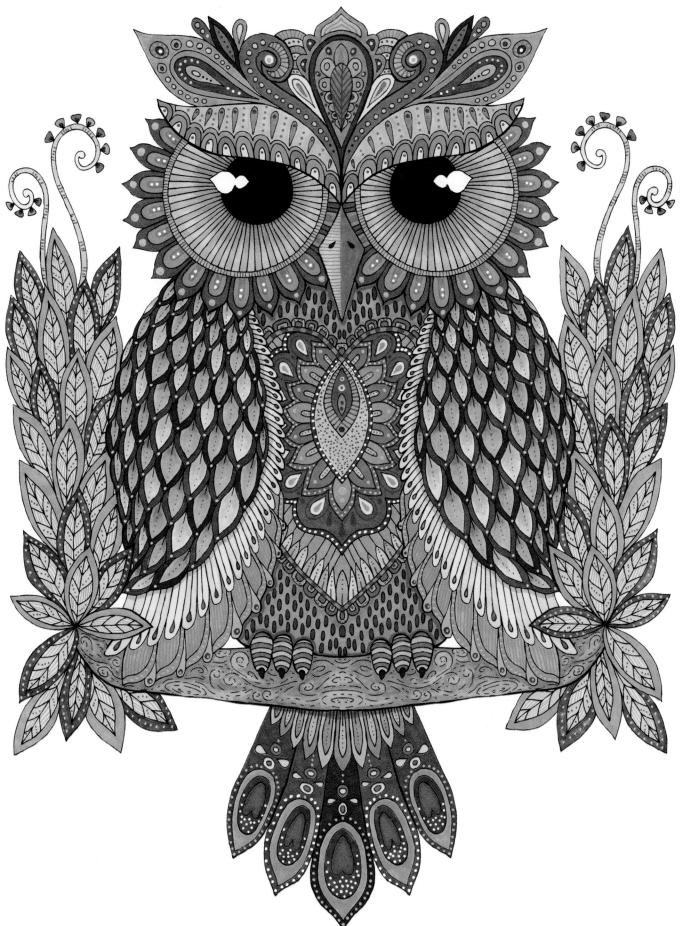

Hello Angel #1203, markers, pens, paint pens

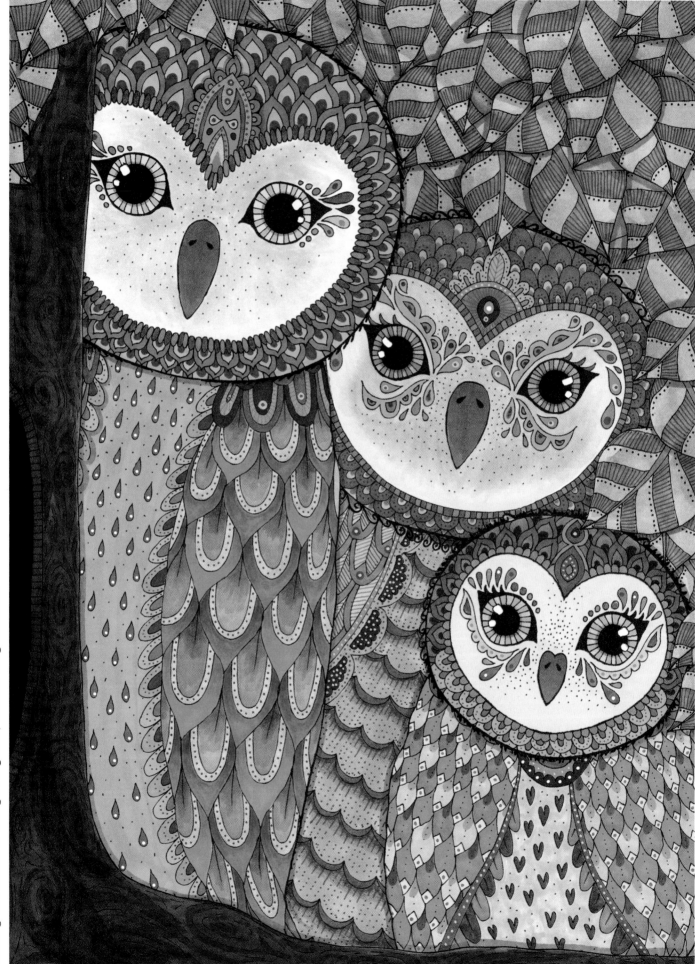

Hello Angel #1217, liquid watercolor, markers, colored pencils, pens, paint pens

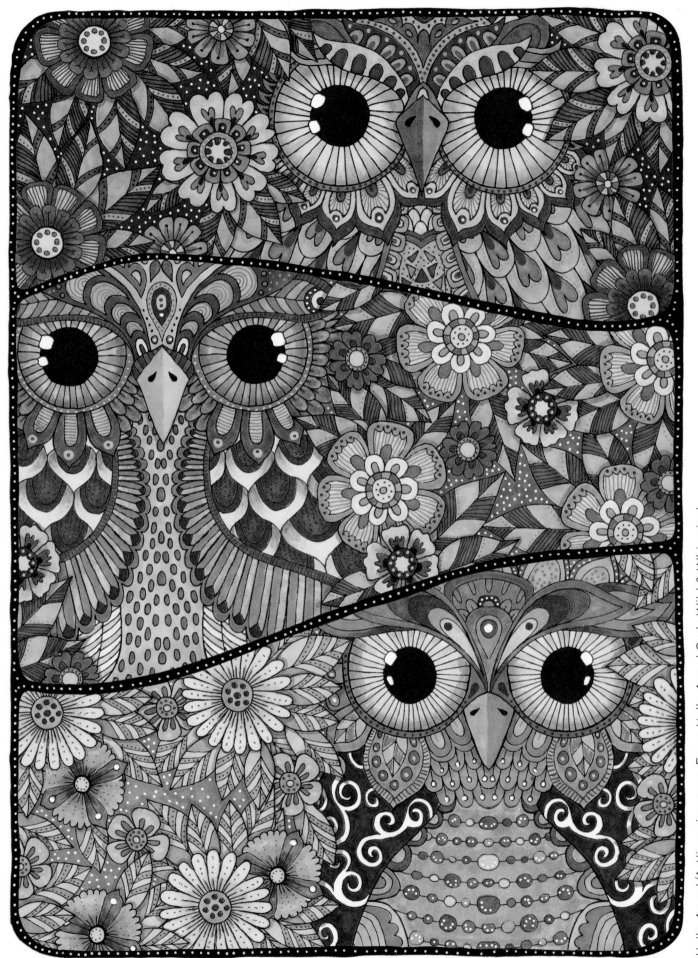

Hello Angel #1204, markers, colored pencils, pens, paint pens

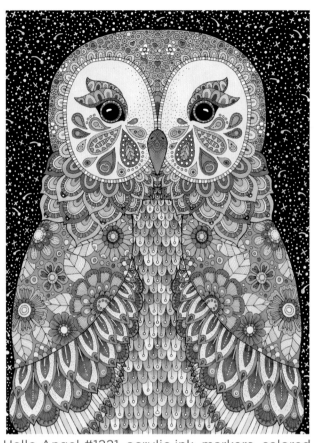

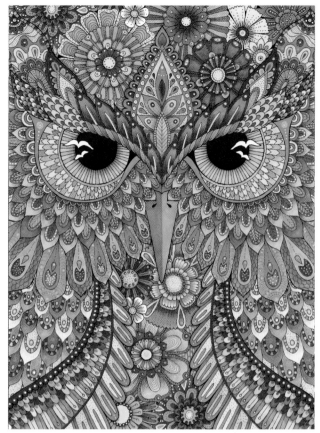

Hello Angel #1221, acrylic ink, markers, colored pencils, pens, paint pens

Hello Angel #1202, markers, colored pencils, pens, paint pens

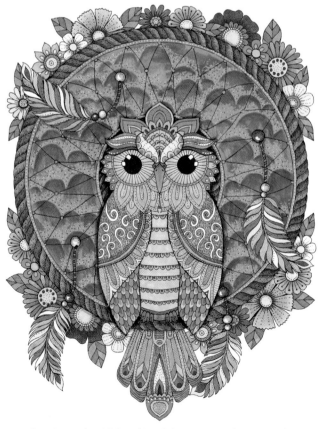

Hello Angel #1205, liquid watercolor, markers, colored pencils, pens, paint pens

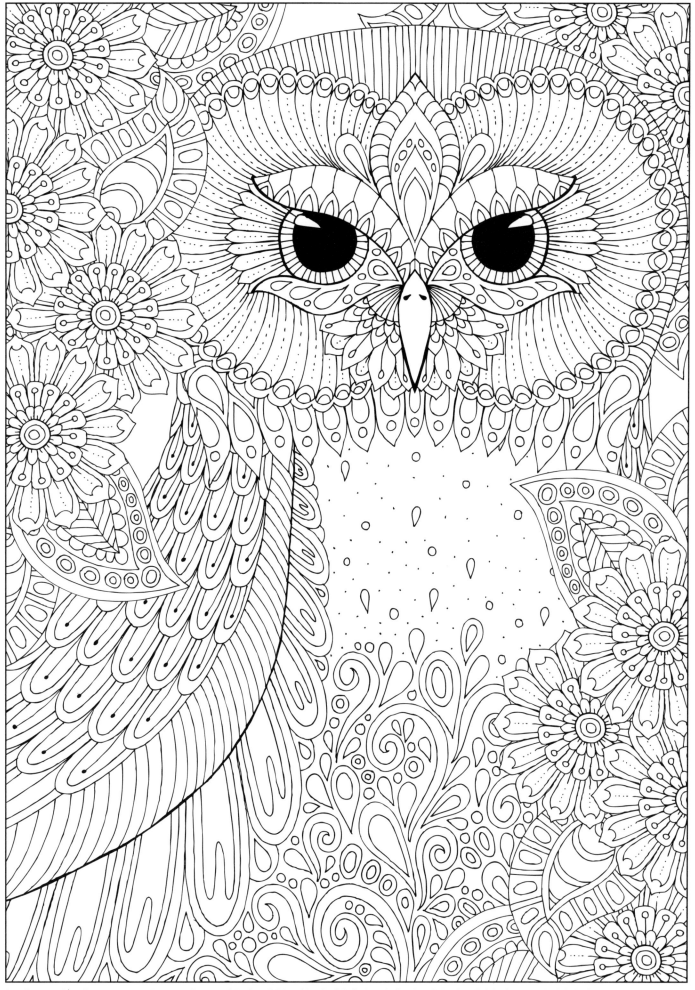

My soul is in the sky.

—WILLIAM SHAKESPEARE, *A MIDSUMMER NIGHT'S DREAM*

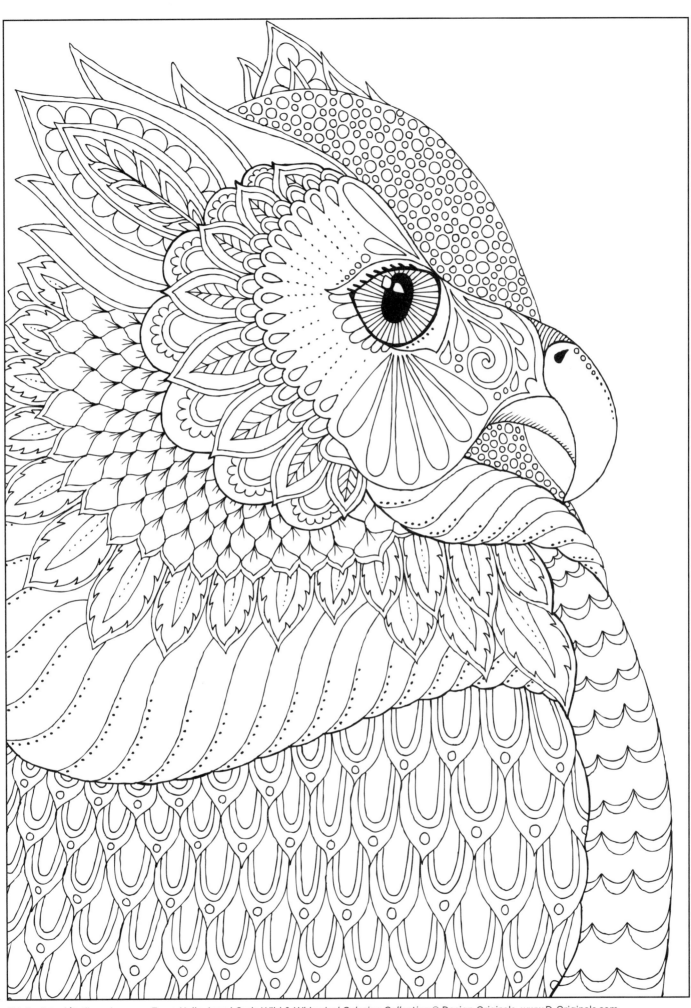

A certain darkness is needed to see the stars.

—OSHO

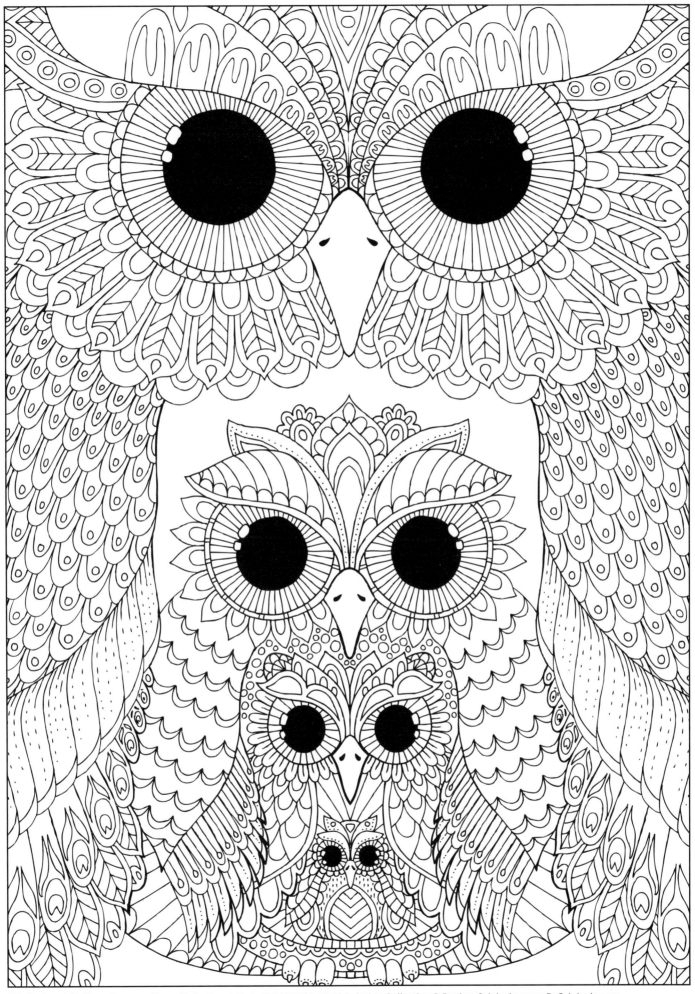

The wisdom you seek is already within you.

—UNKNOWN

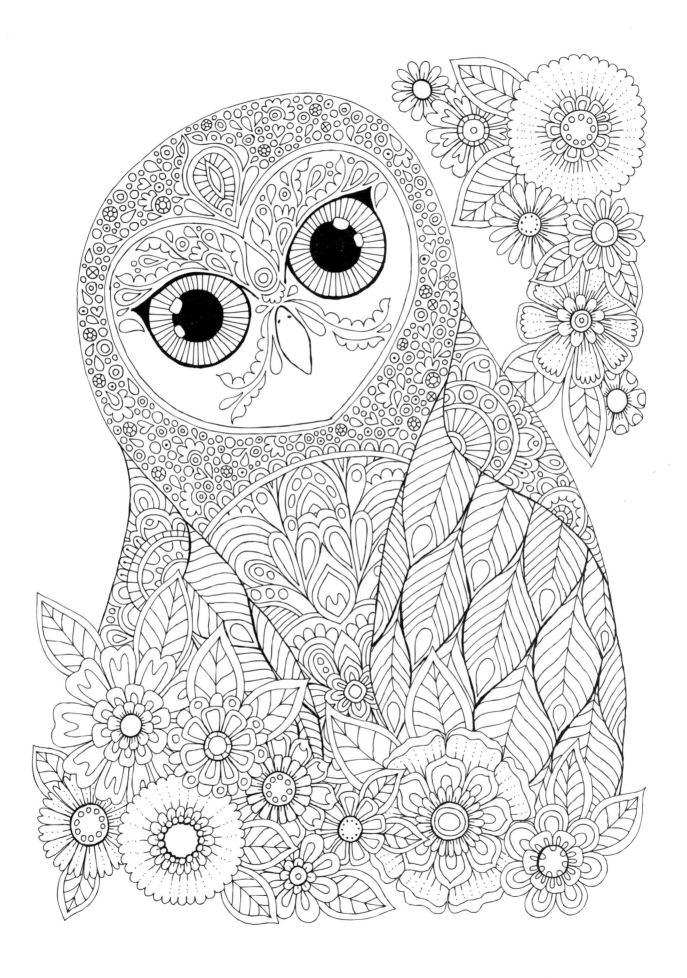

It is not in the stars to hold our destiny
but in ourselves.

—WILLIAM SHAKESPEARE, *JULIUS CAESAR*

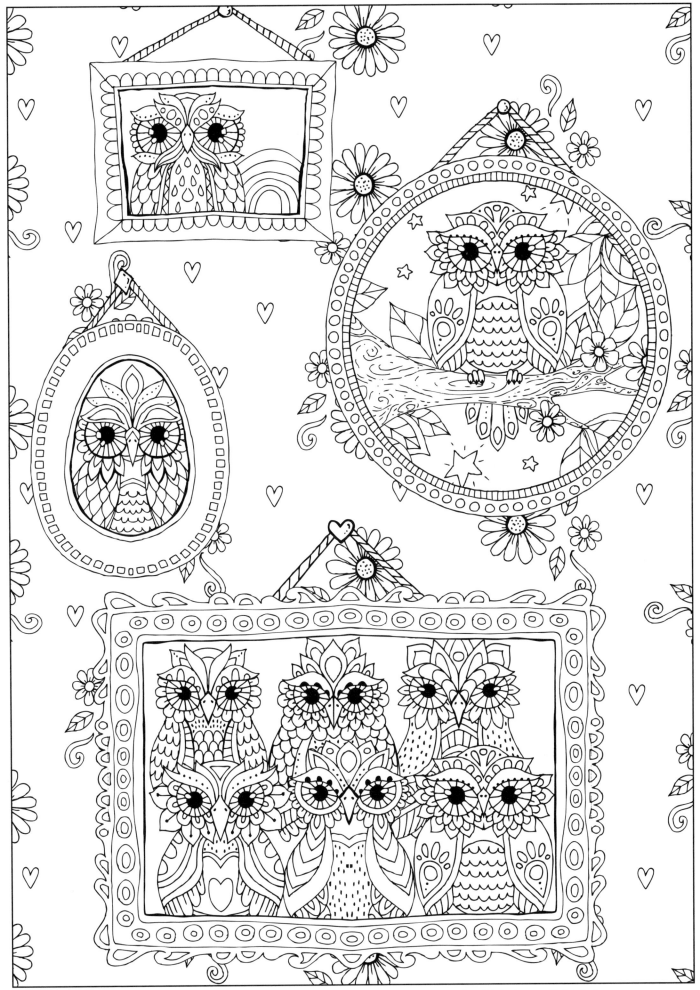

Think of the happiest things,
it's the same as having wings.

—"YOU CAN FLY," *PETER PAN*

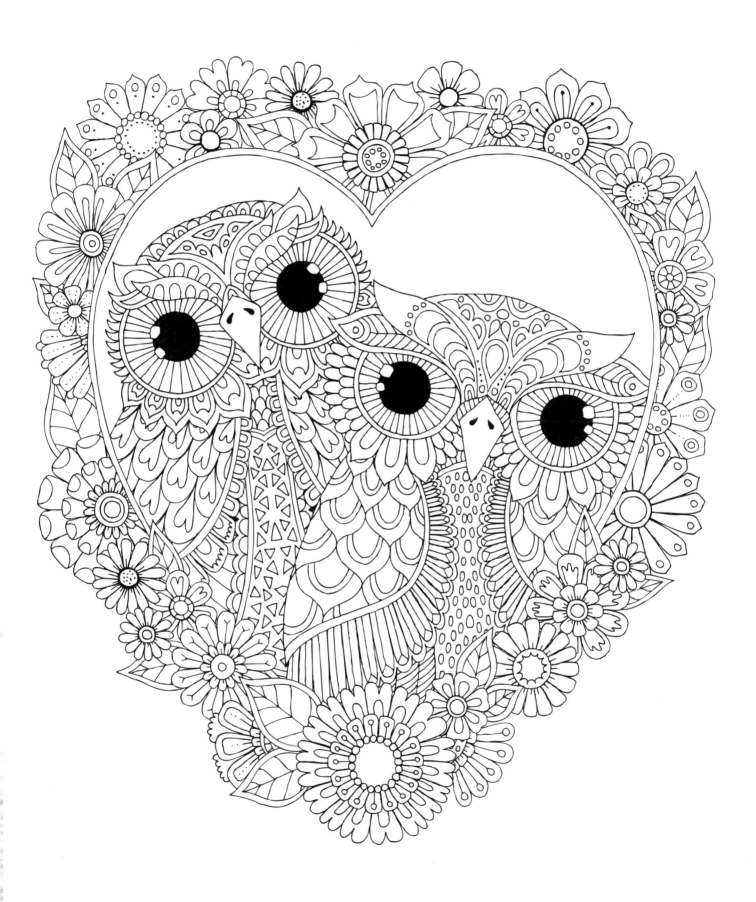

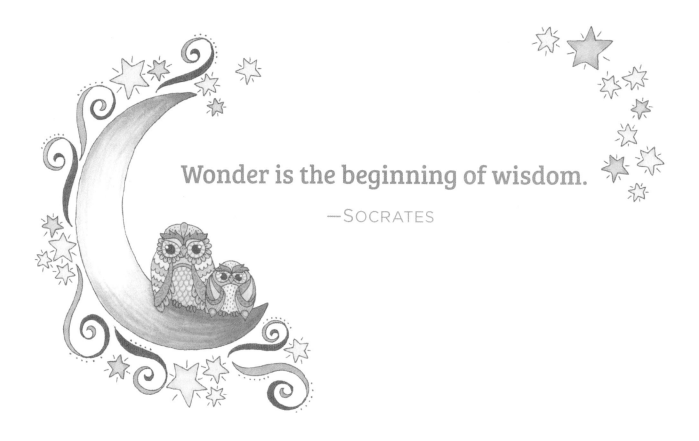

Wonder is the beginning of wisdom.

—SOCRATES

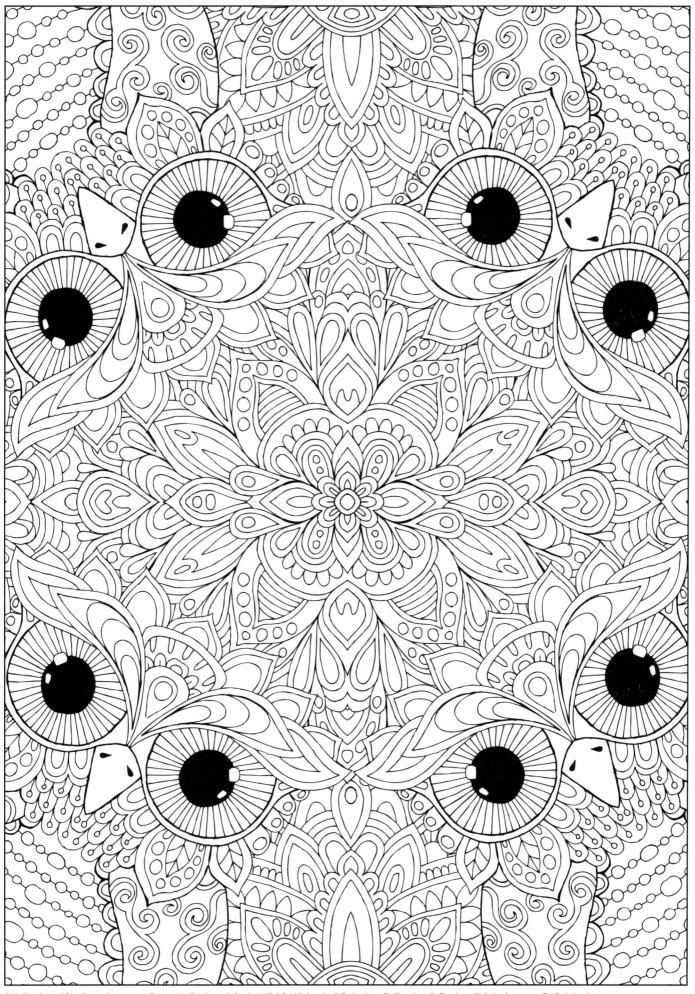

It is a happiness to wonder;
it is a happiness to dream.

—EDGAR ALLAN POE

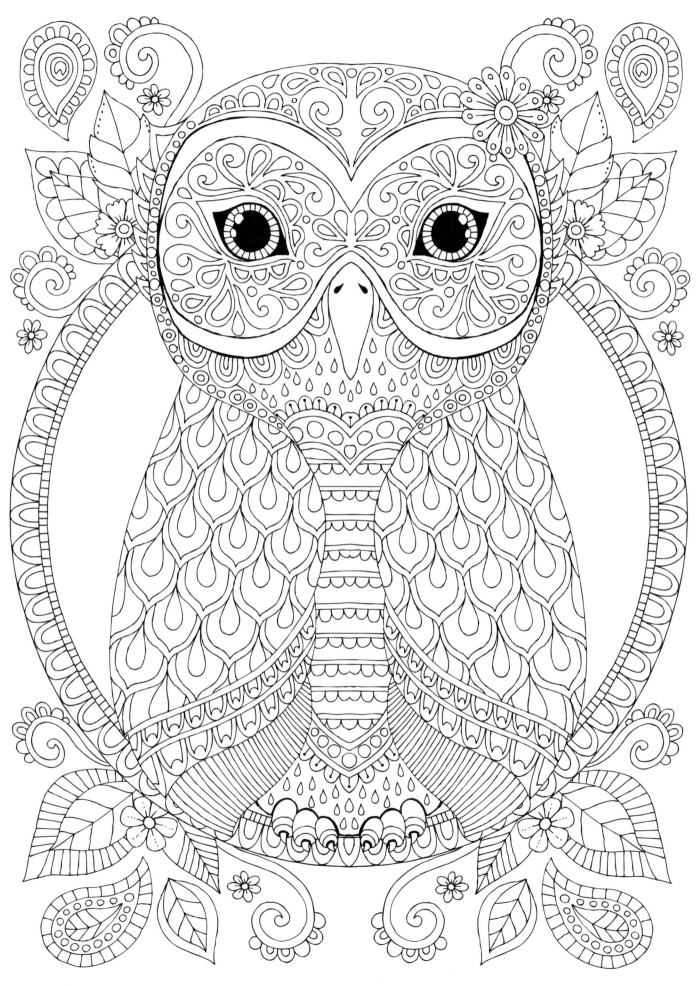

I have loved the stars too fondly
to be fearful of the night.

—SARAH WILLIAMS

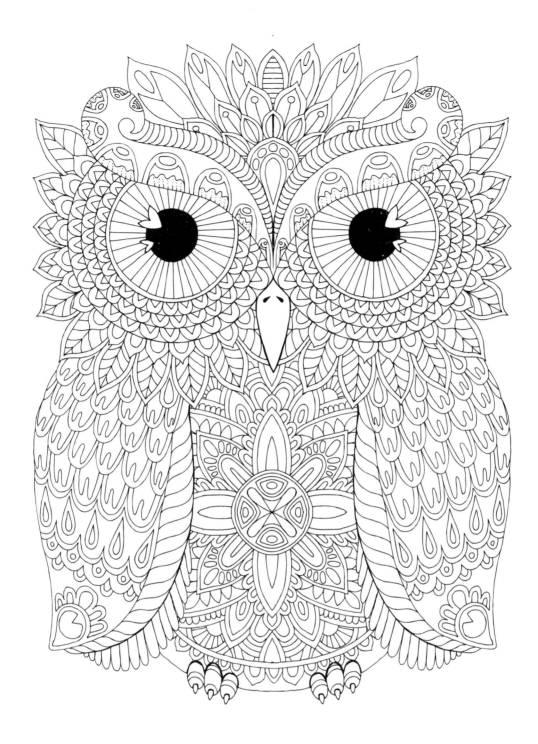

Analogous colors like purple, blue, green, and yellow
will always pair well together.

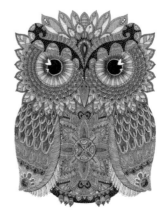

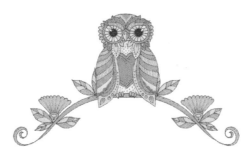

I've always liked the time before dawn
because there's no one around to remind
me who I'm supposed to be, so it's easier
to remember who I am.

—BRIAN ANDREAS

Hello Angel #1201

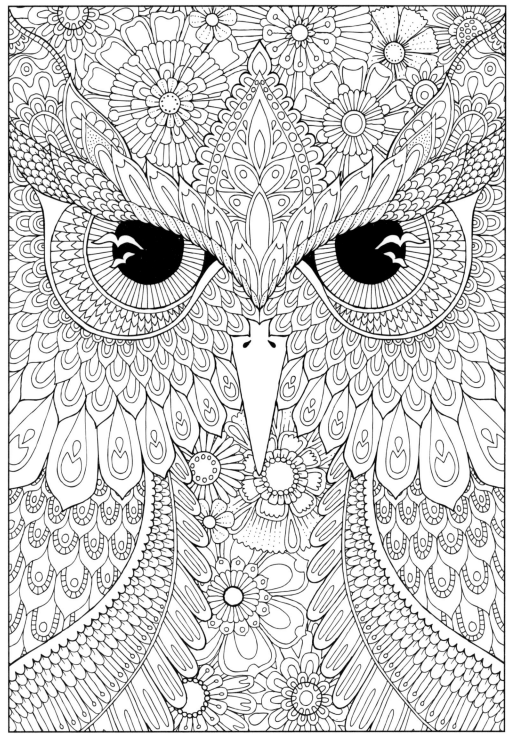

This color palette primarily uses cool colors with a few warm colors added in to provide contrast. Some light research into color theory will help you gain confidence choosing colors.

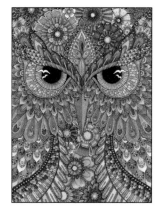

Dreaming, after all, is a form of planning.

—GLORIA STEINEM

Hello Angel #1202

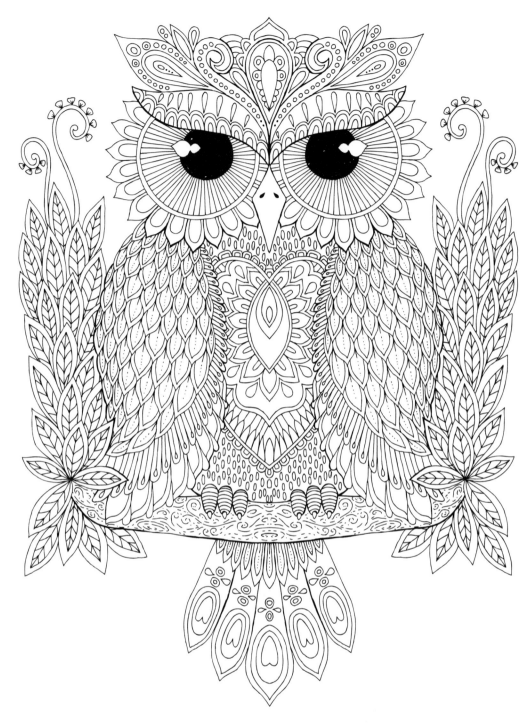

Try complementary color pairings like blue and orange and purple and yellow for bold contrast.

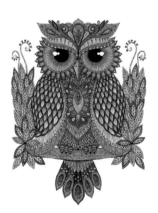

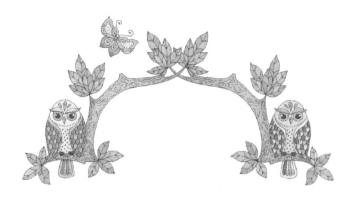

Let your dreams take flight.

—UNKNOWN

Hello Angel #1203

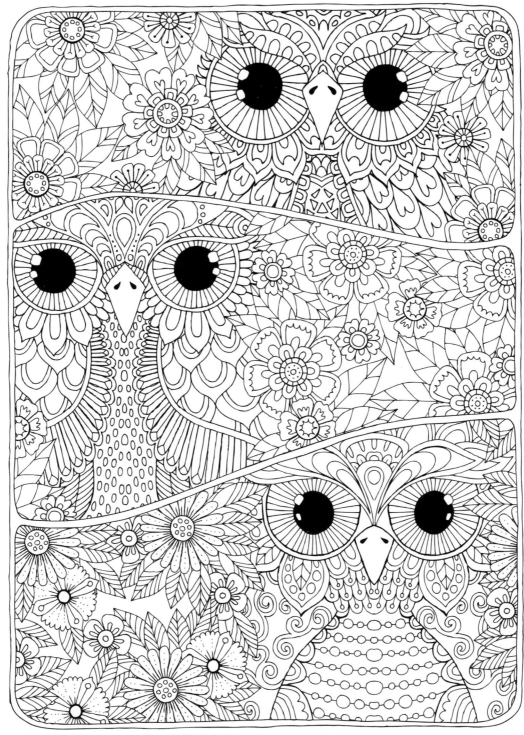

Warm colors like yellow and orange will stand out in a design while cool colors like blue and purple will recede. Try using warm colors for the owls' eyes.

Remember to look up at the stars and not down at your feet.

—STEPHEN HAWKING

Hello Angel #1204

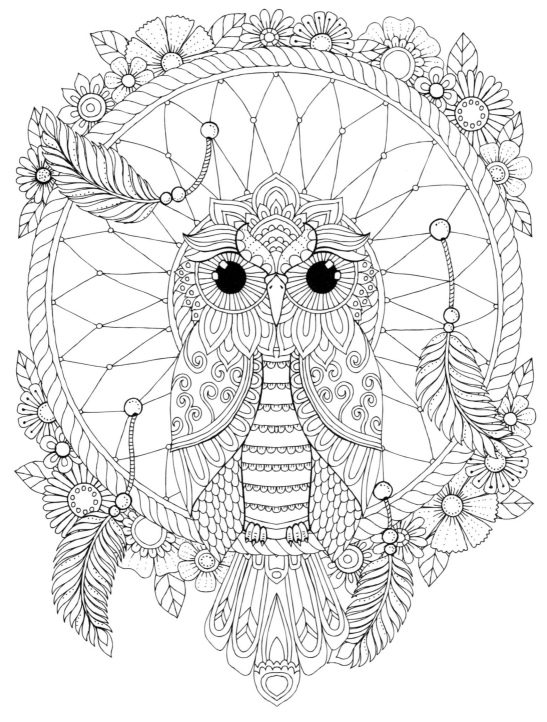

Use a deep, rich color for the background and light or bright colors for the other elements, allowing them to pop off the background color.

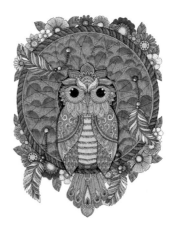

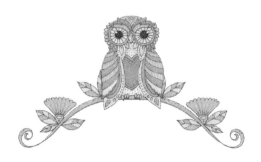

May the wind under your wings bear you
where the sun sails and the moon walks.

—J. R. R. TOLKIEN

Hello Angel #1205

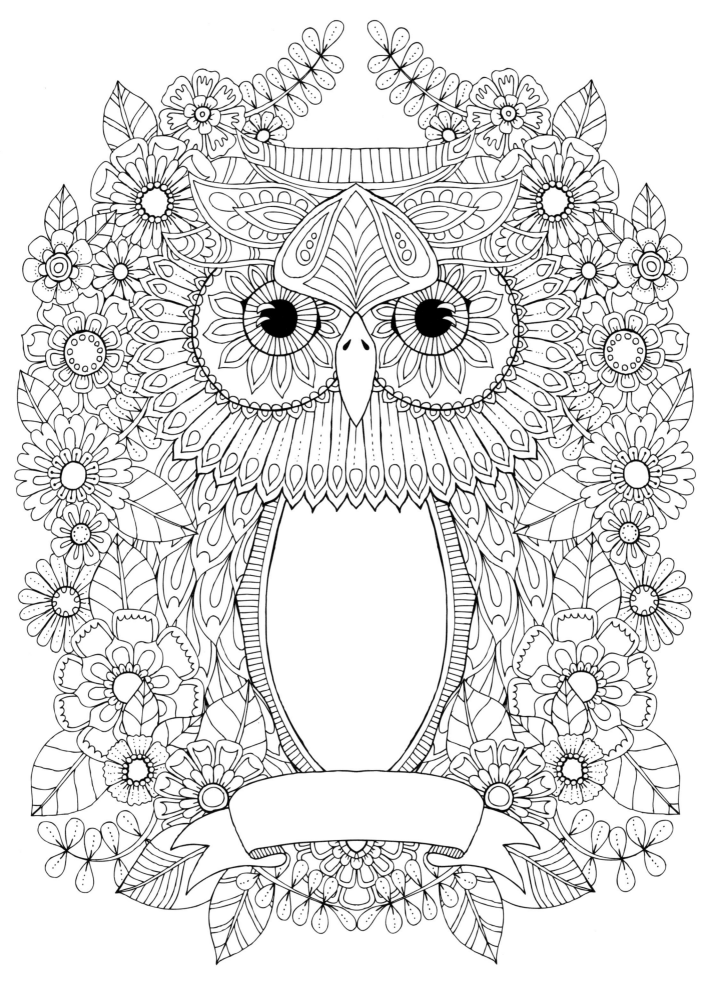

To imagine—to dream about things that have not happened—is among mankind's deepest needs.

—Milan Kundera

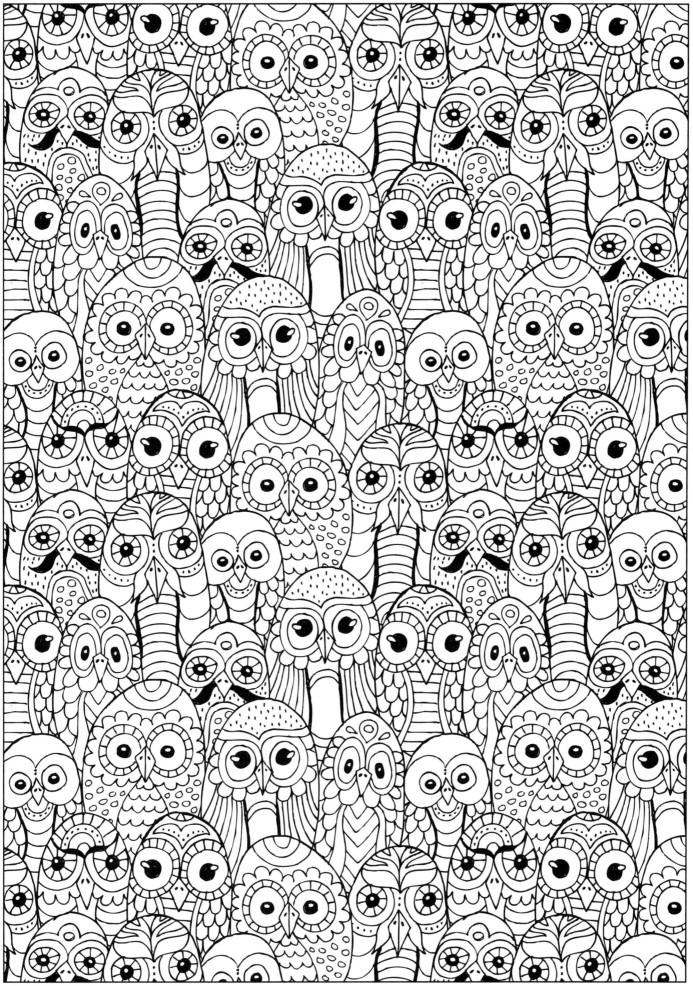

The wisest mind has something yet to learn.

—GEORGE SANTAYANA

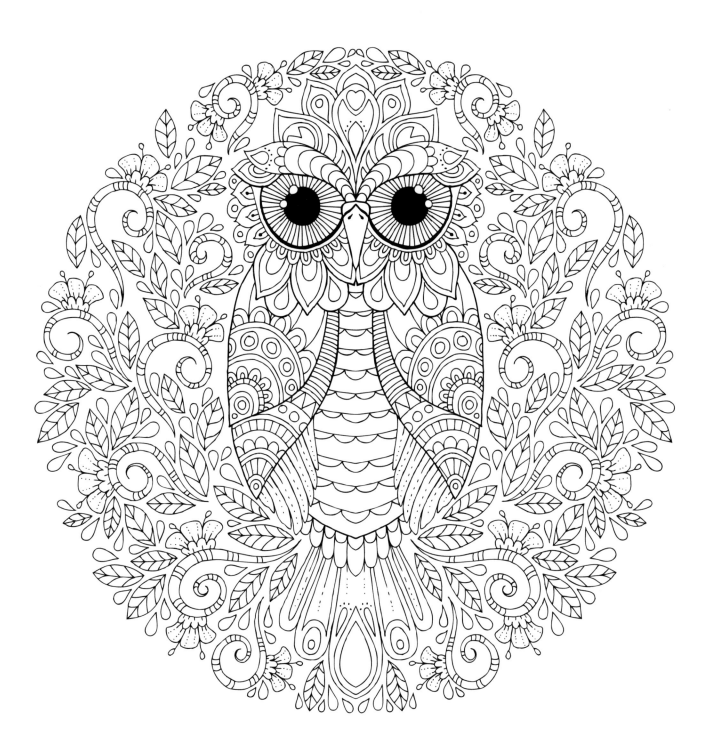

Life holds a special magic
for those who dare to dream.

—Unknown

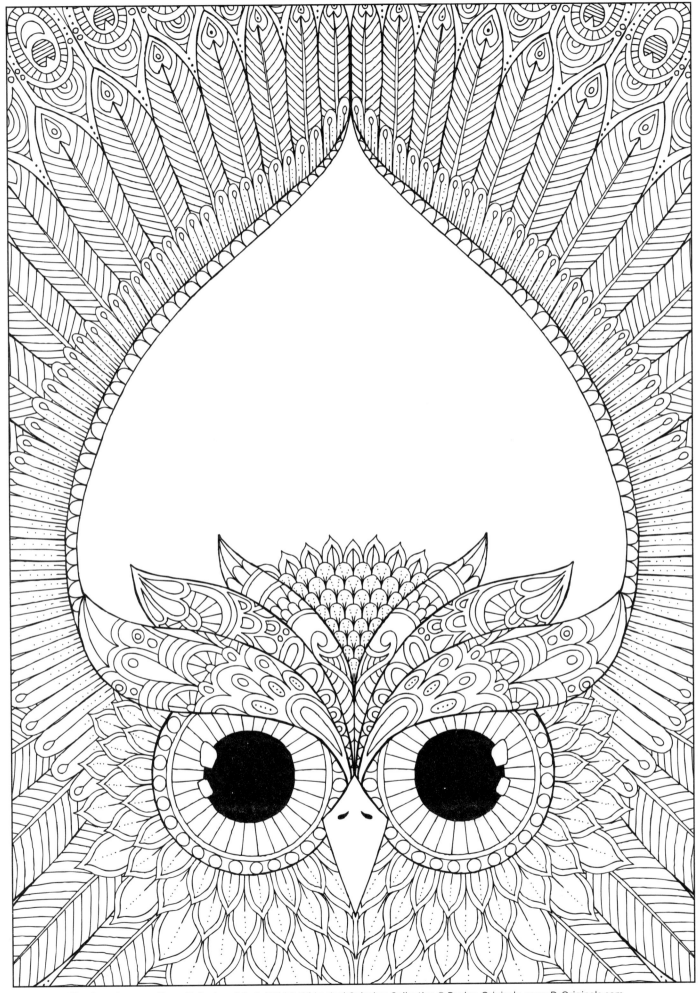

No bird soars too high,
if he soars with his own wings.

—William Blake

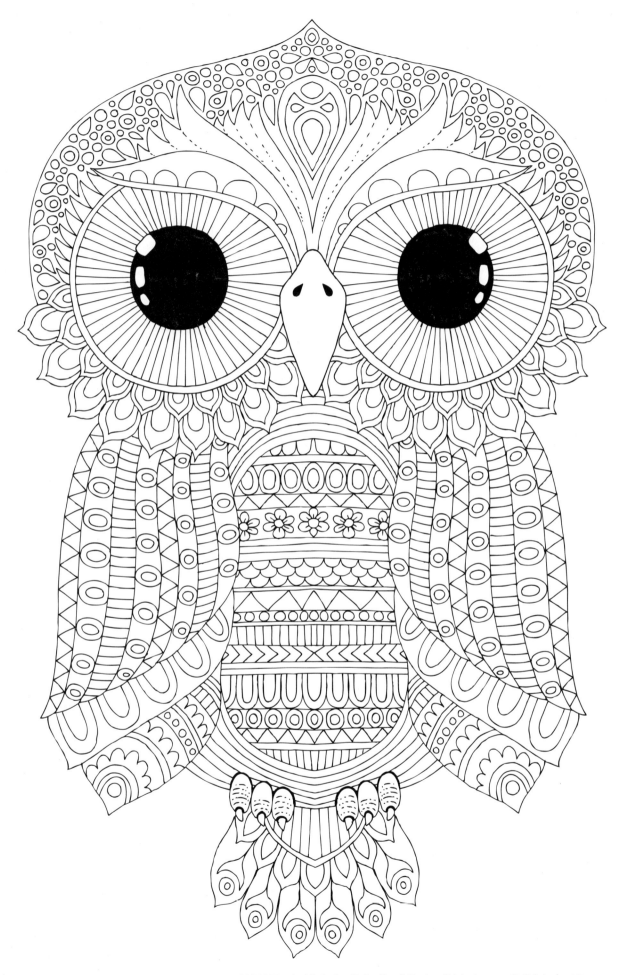

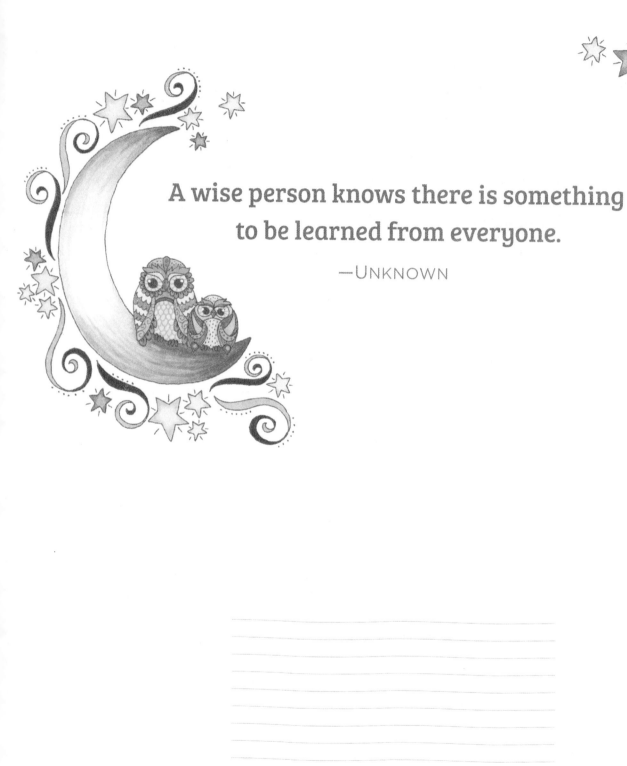

A wise person knows there is something to be learned from everyone.

—UNKNOWN

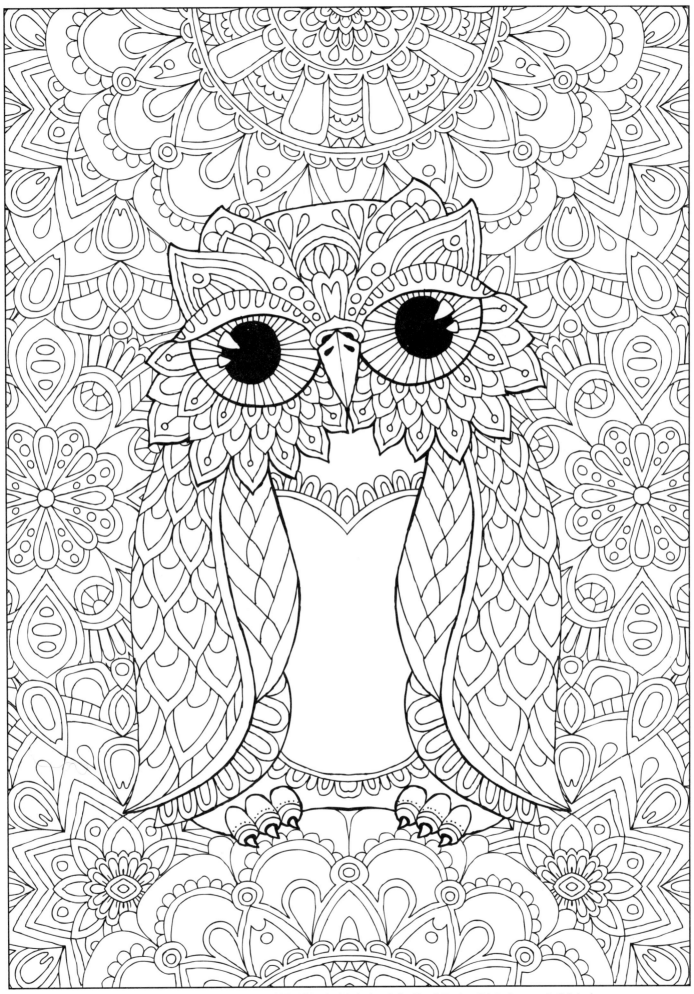

I am a daydreamer and a night thinker.

—UNKNOWN

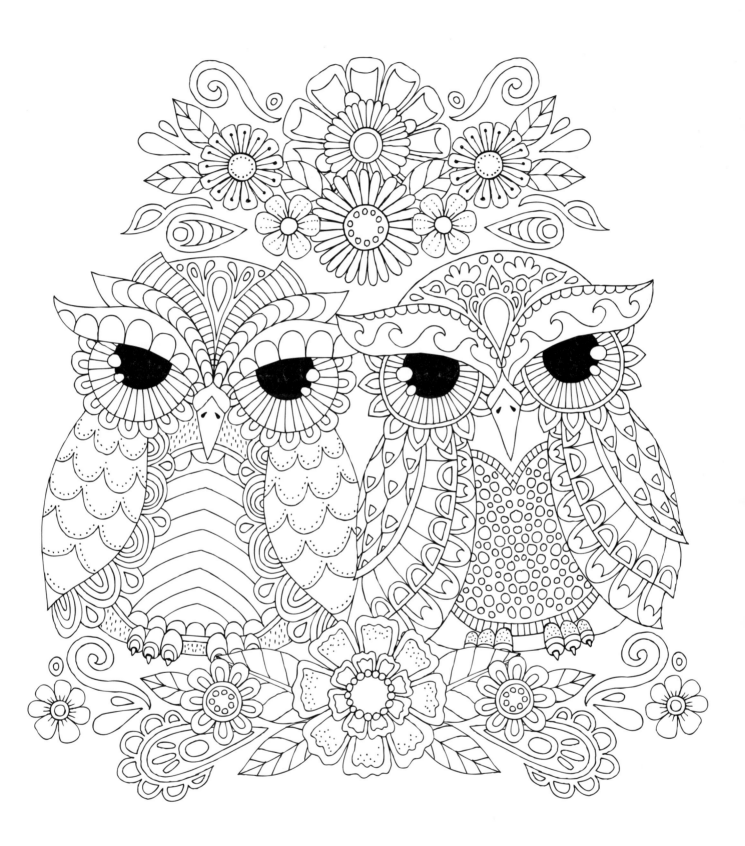

Knowledge speaks, but wisdom listens.

—Unknown

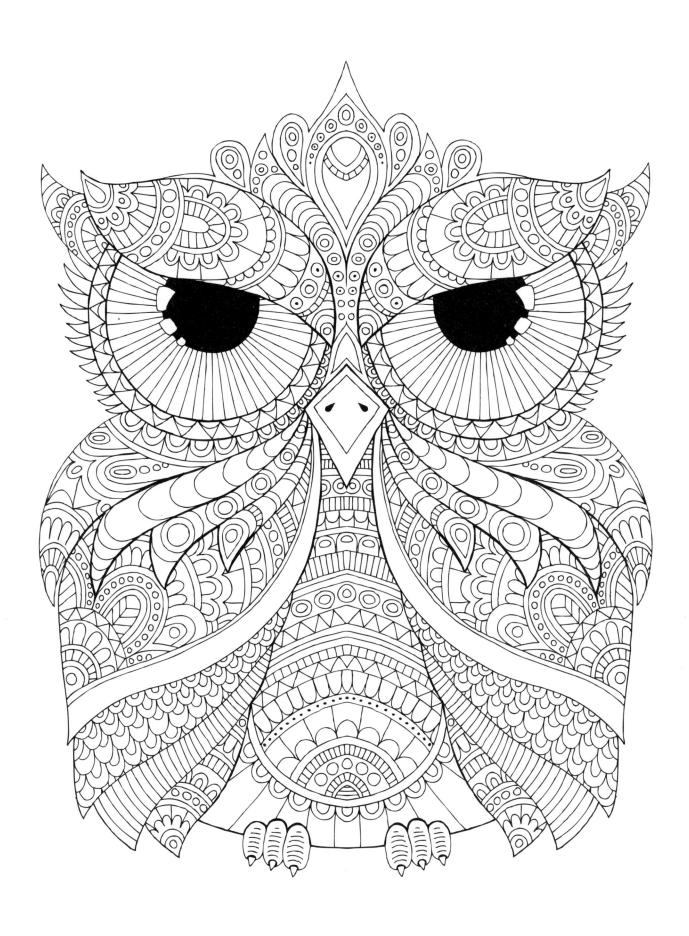

Until you spread your wings
you have no idea how far you'll fly.

—UNKNOWN

I don't dream at night, I dream all day.
I dream for a living.

—STEVEN SPIELBERG

At night when the stars light up my room,
I sit by myself talking to the moon.

—BRUNO MARS, *TALKING TO THE MOON*

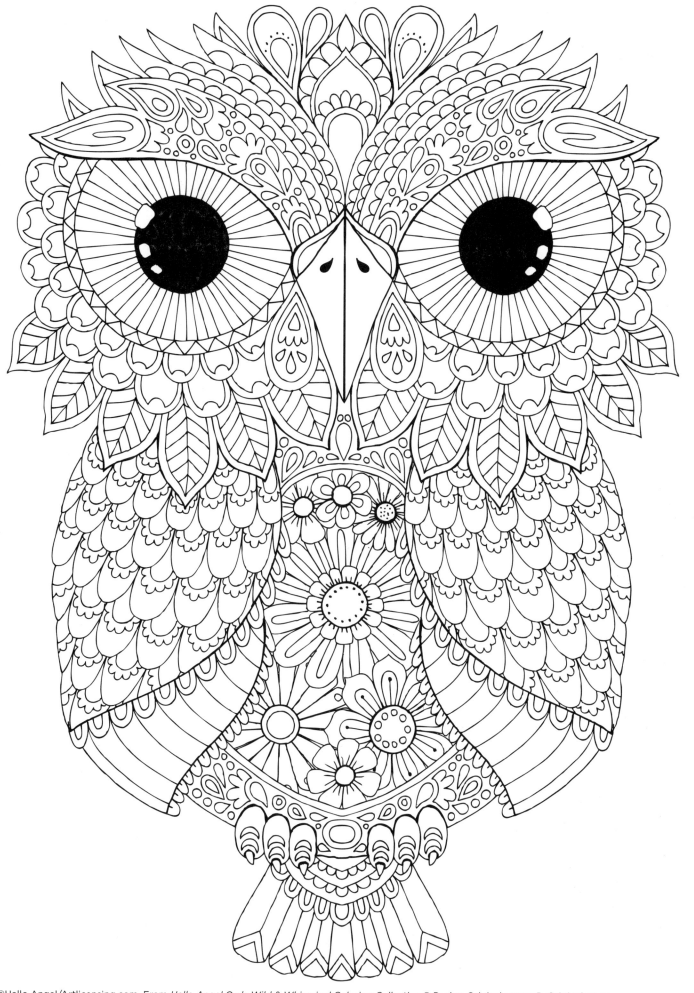

Fly without wings,
Dream with open eyes,
See in darkness.

—DEJAN STOJANOVIC

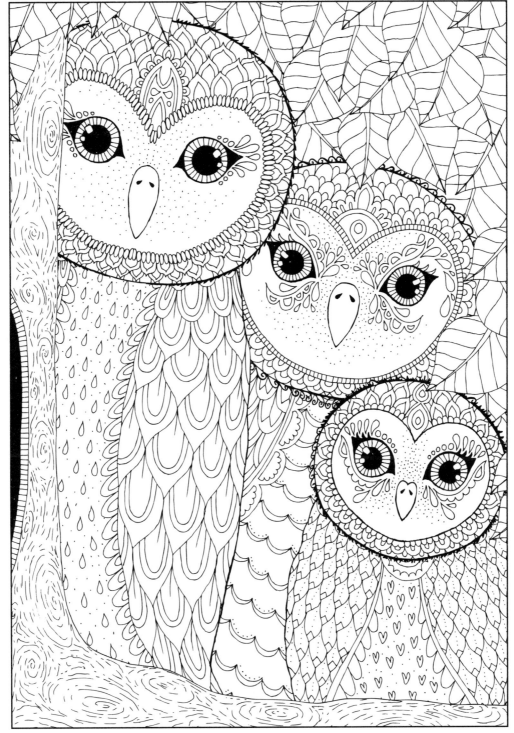

Complementary colors like the blue and orange in the large owl's wing and yellow and purple in the small owl's face will really stand out against one another.

You have escaped the cage.
Your wings are stretched out. Now fly.

—RUMI

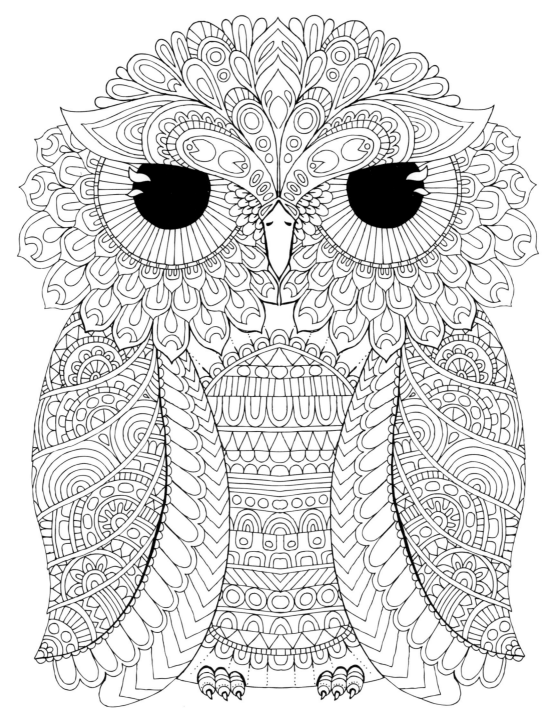

Pairing warm colors, like yellow, orange, and pink, against cool colors, like blue, purple, and green, will allow the colors to stand out against one another.

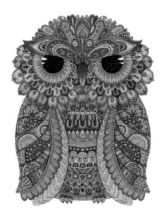

I dream, therefore I am.

—Unknown

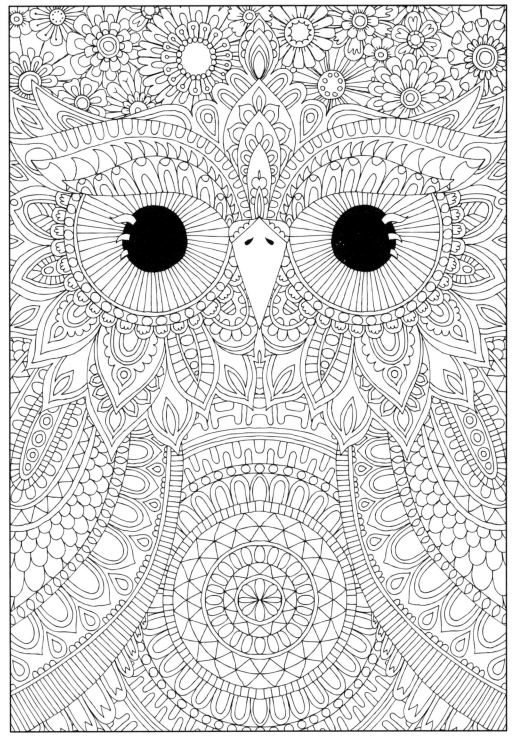

©Hello Angel/Artlicensing.com, From *Hello Angel Owls Wild & Whimsical Coloring Collection* © Design Originals, www.D-Originals.com

Use the natural world as inspiration for your color choices. This owl features shades of brown, as you would see in nature, but also lots of other fun, vibrant colors.

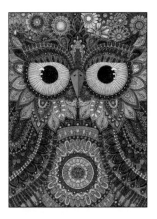

May your wings be strong. May they carry you above the clouds and into the headwinds. May they never falter. Not even once.

—MALEFICENT

Hello Angel #1219

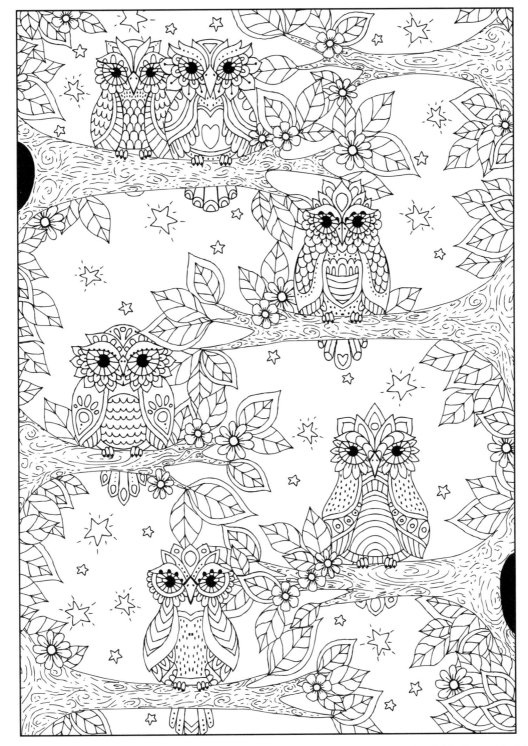

A dark background like the one used for this design allows the other elements to shine.

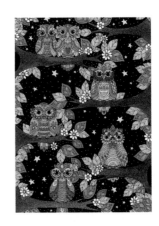

For my part I know nothing
with any certainty, but the sight
of the stars makes me dream.

—Vincent van Gogh

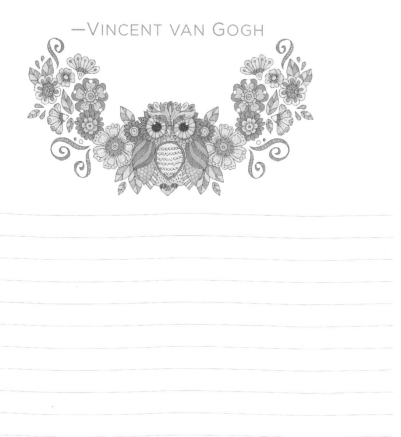

Hello Angel #1220

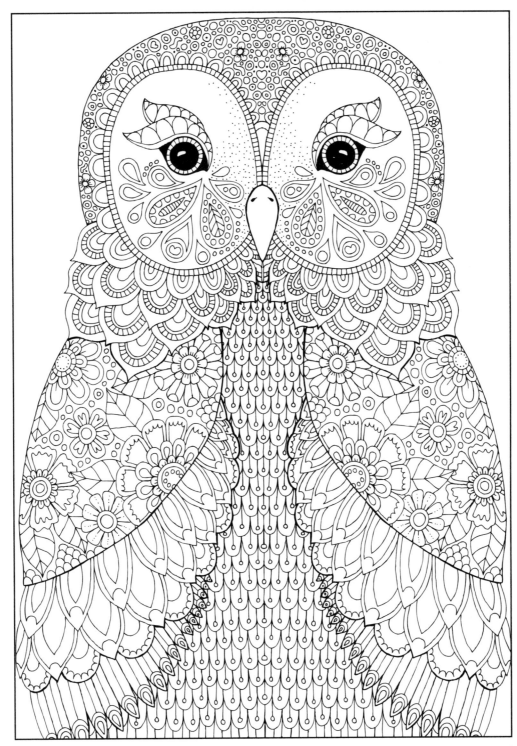

©Hello Angel/Artlicensing.com, From *Hello Angel Owls Wild & Whimsical Coloring Collection* © Design Originals, www.D-Originals.com

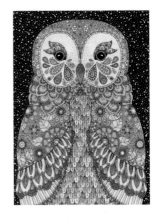

Get creative with your backgrounds by adding patterning, like the white stars added to the black background of this example.

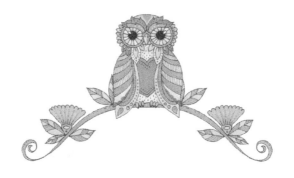

Knowing yourself is the
beginning of all wisdom.

—ARISTOTLE

Hello Angel #1221

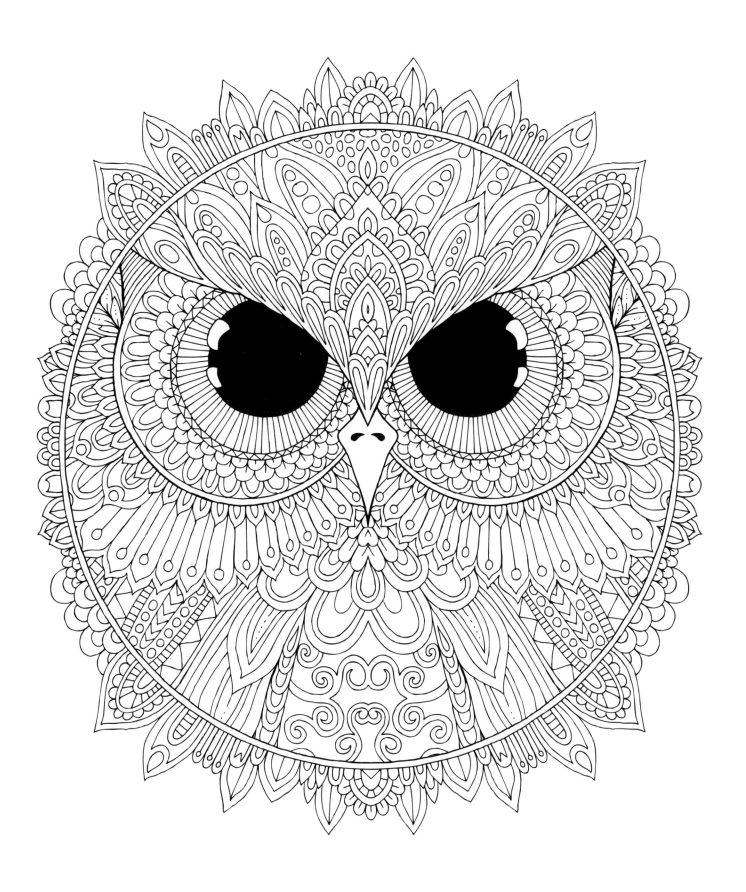

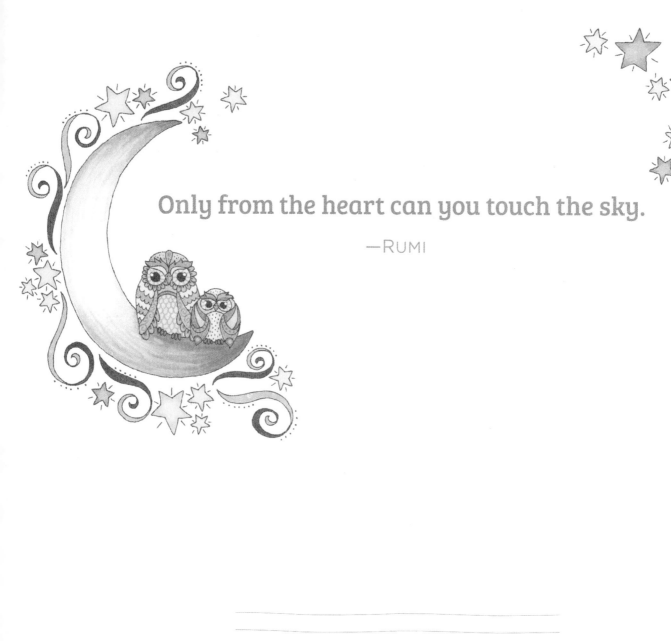

Only from the heart can you touch the sky.

—RUMI

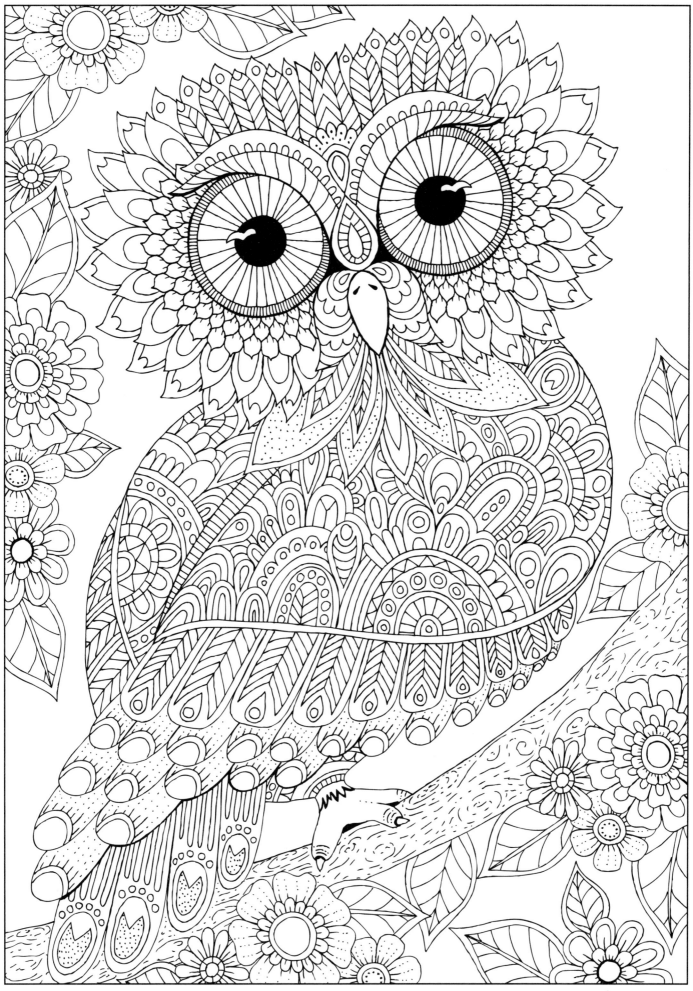

I believe that if one always looked at the skies,
one would end up with wings.

—GUSTAVE FLAUBERT

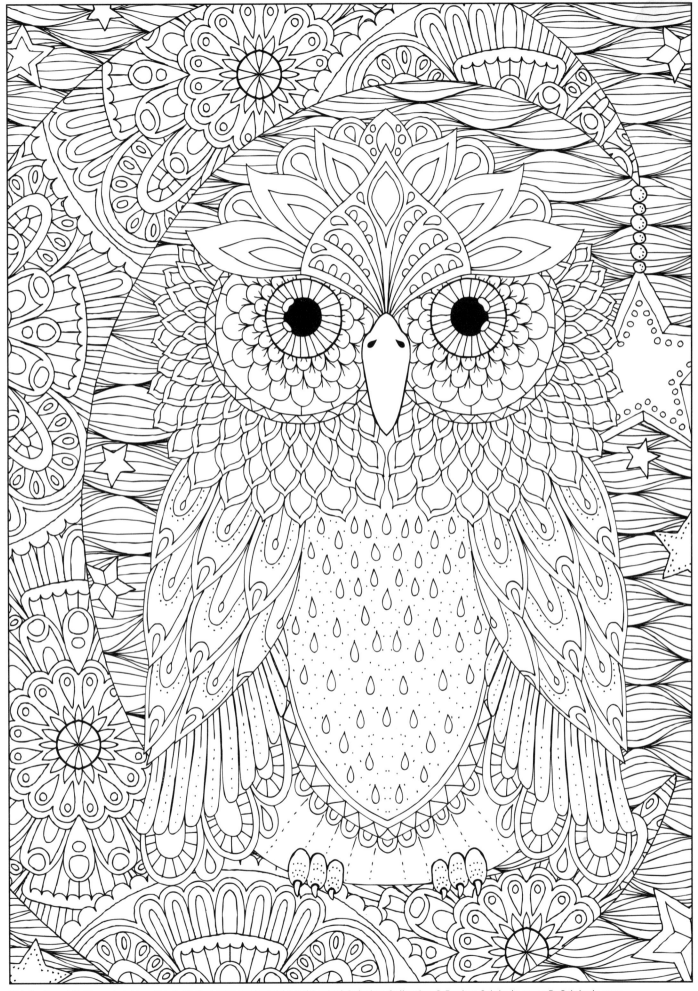

Oh how you shine with your heart full
of moonlight and your soul full of stars.

—Unknown

